SWEARY CATS

Pavilion
An imprint of HarperCollins*Publishers* Ltd
1 London Bridge Street
London SE1 9GF

www.harpercollins.co.uk

HarperCollins*Publishers*
Macken House,
39/40 Mayor Street Upper,
Dublin 1
D01 C9W8

10 9 8 7 6 5 4 3 2 1

First published in Great Britain by
Pavilion, an imprint of HarperCollins*Publishers* 2023

ISBN 978-0-008589-02-8

This book is produced from independently certified FSC™ paper
to ensure responsible forest management.

For more information visit:
www.harpercollins.co.uk/green

Printed and bound in China by RR Donnelley, APS

SWEARY CATS

ANDREW DAVIES

PAVILION

Despicable Meow

"Cats have a scam going. You buy the food, they eat the food, they go away. That's the deal." Not my words, but those of Eddie Izzard describing her relationship with cats in a classic stand-up routine. Many think that cats are empathetic pets, uber cool, aware of people's feelings, who will nuzzle up when their owner is tearful and lick away their tears. Or maybe they just want the salt. Or maybe it's a health check to make sure the person who opens the moist pouches will still be available to open the next one in the cupboard. That vigorous rubbing at the back of the calves doesn't come from

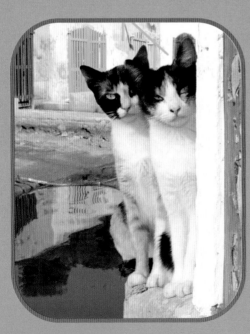

a spontaneous outburst of emotion, it happens at meal times. Dogs, on the other hand, want to be your best friend all the time. Dogs want to help you, guard you, fetch things (provided the thing is a stick or a heavily salivated tennis ball). Cats want to get on with their lives. They have their own

agenda, and if you interrupt it, they are seriously annoyed. They'll tolerate being picked up, but not for long. This book articulates some of the thoughts that run through a cat's mind when that happens, from the mildly hissed off; such as Martin, who's watching his favourite *Bagpuss* episode; to Abigail, who can't work out where the ginger kitten came from in her litter. Cats can be very cruel in both deed and word. Think of the two Siamese cats in the original, animated *Lady and the Tramp*: to Aunt Sarah they are her darling, pedigree pussies who can do no wrong. The minute her back is turned they wreak havoc in the house and stick the blame on someone else. That's what cats are like. They don't need to look like 'Zara – the cat with the cloak made from her enemy's fur' to be angry and vengeful. They don't need to give you an unblinking green-eyed stare to know that they are calculating and manipulative. They are cats – this is their bag. Welcome to their world...

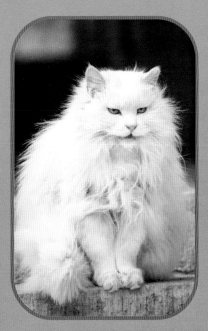

Andrew Davies

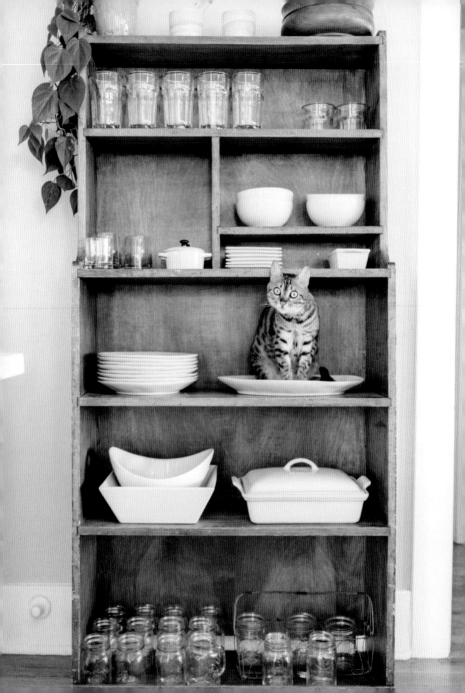

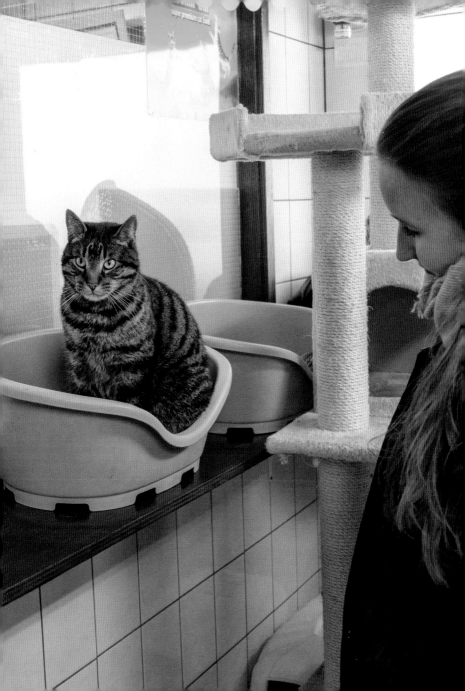

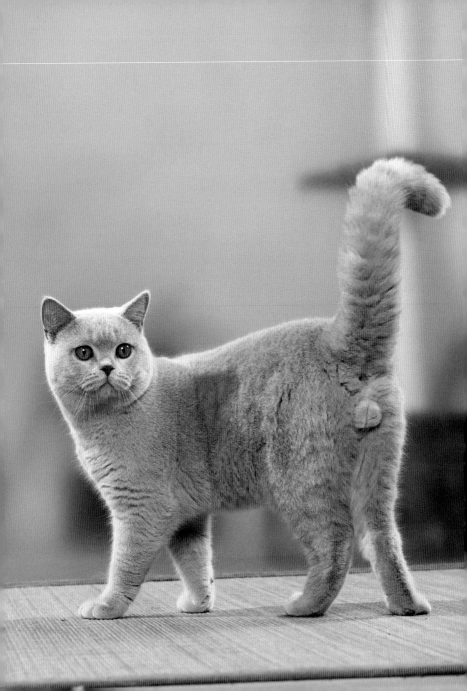

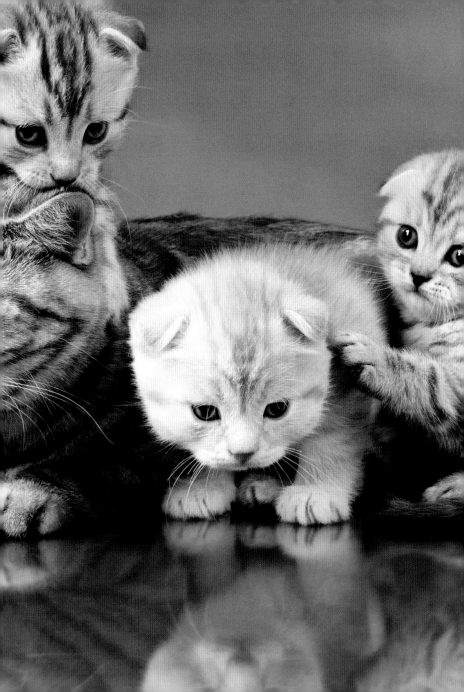

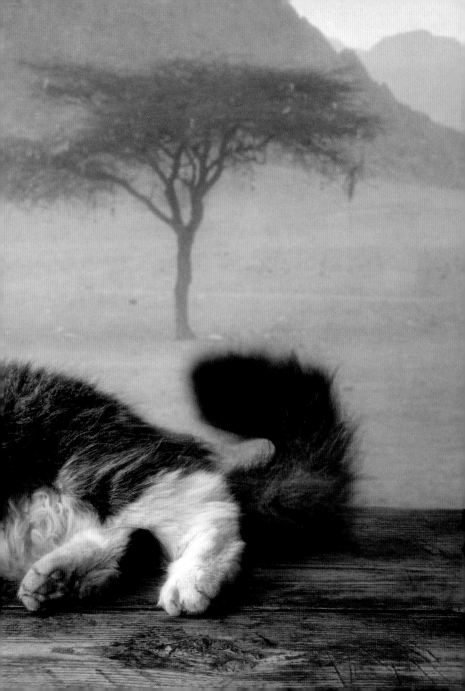

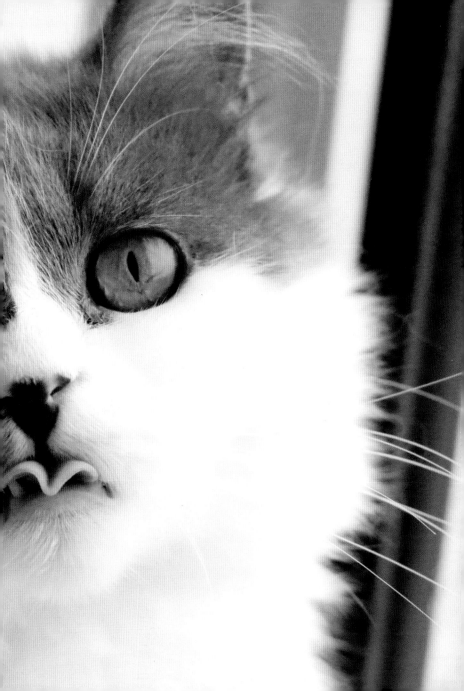

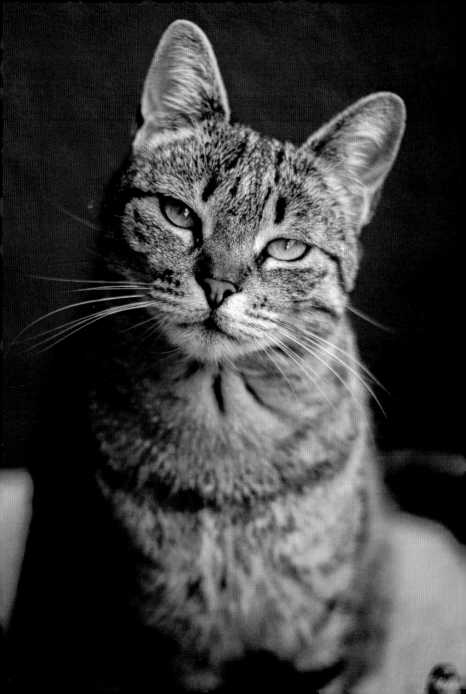

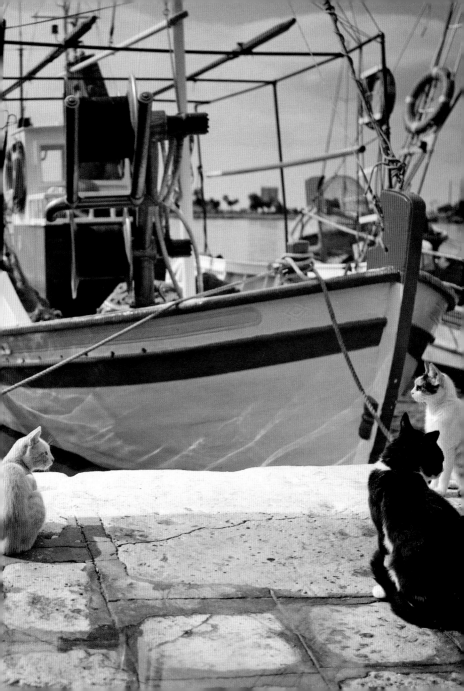

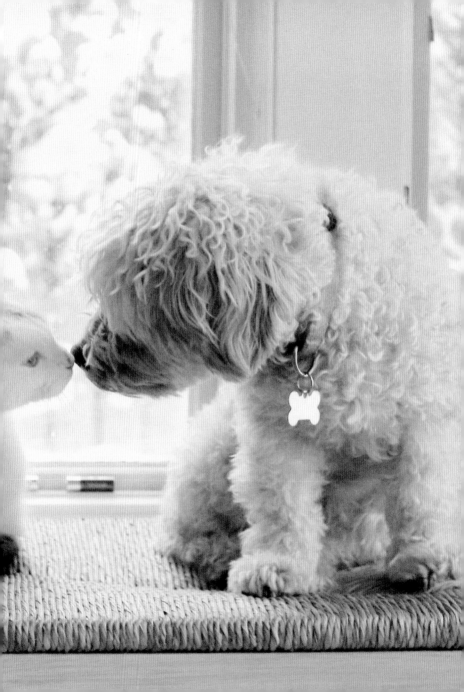

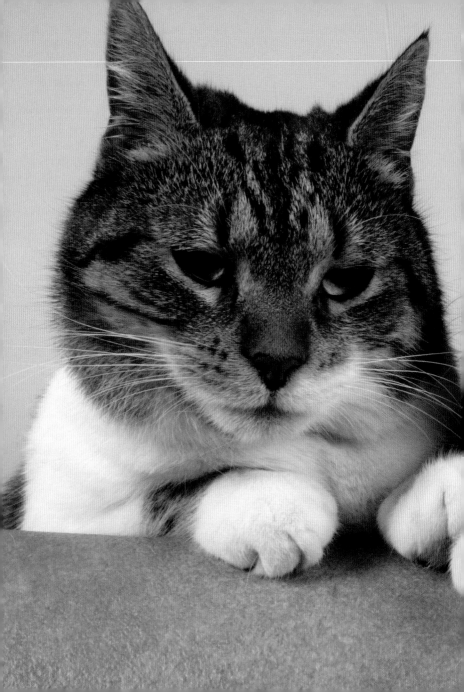

Oh please.
Tell us more about your
snorkelling holiday in the
Maldives...

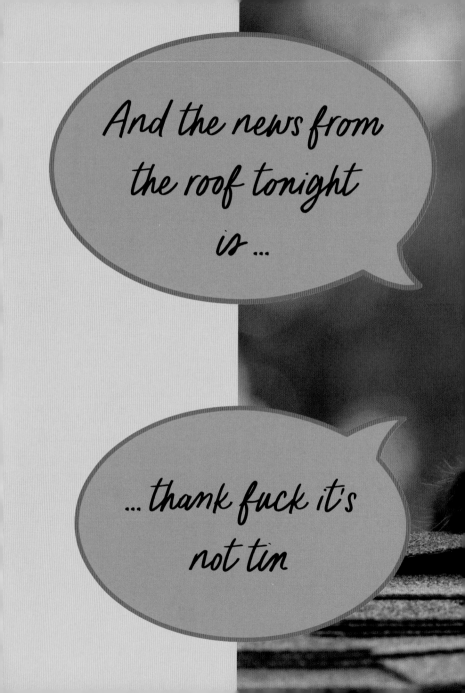

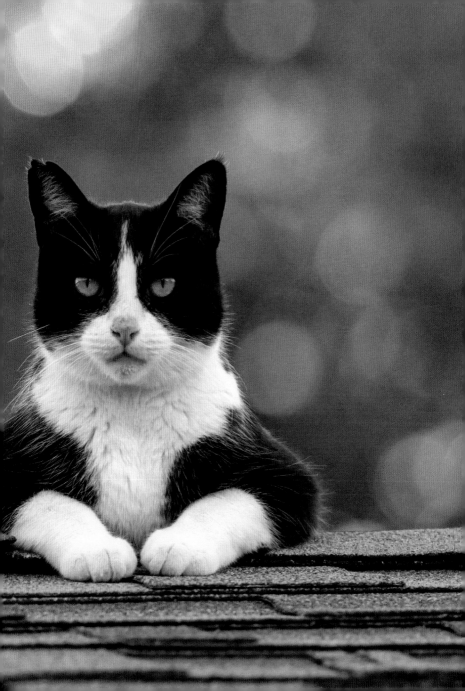

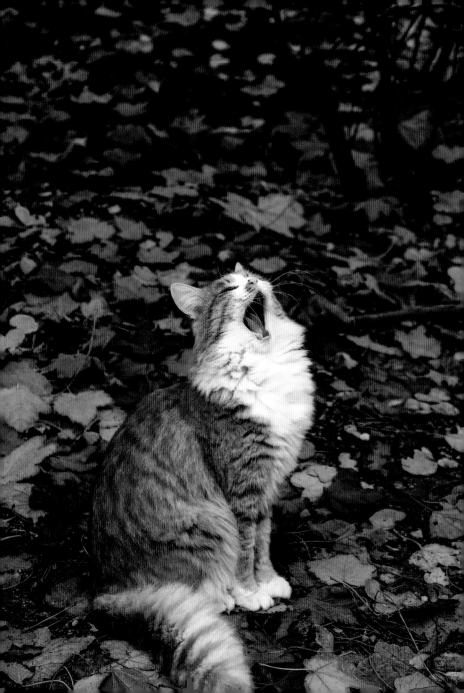

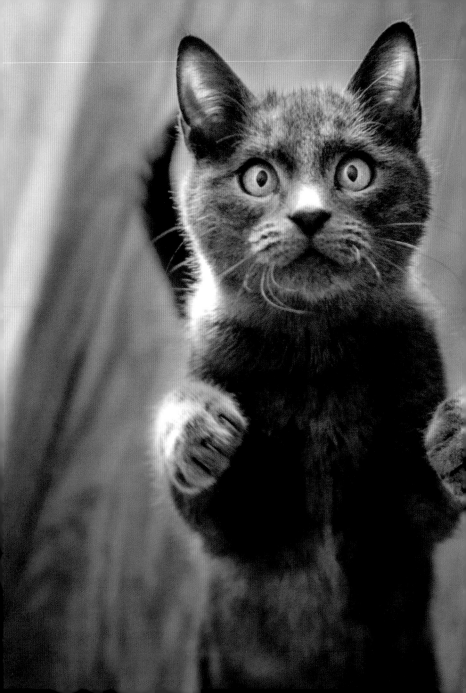

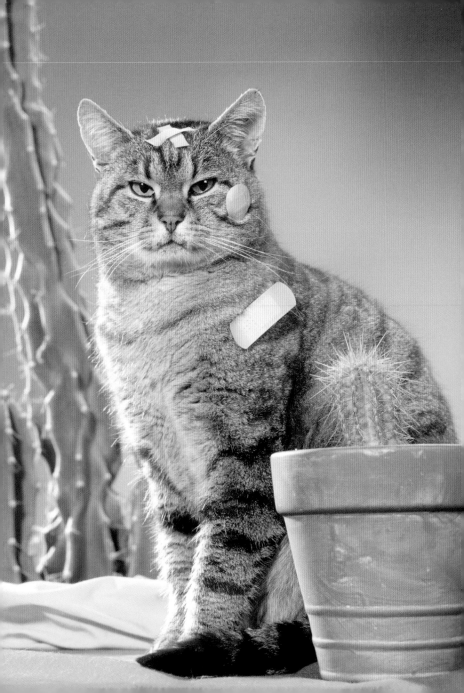

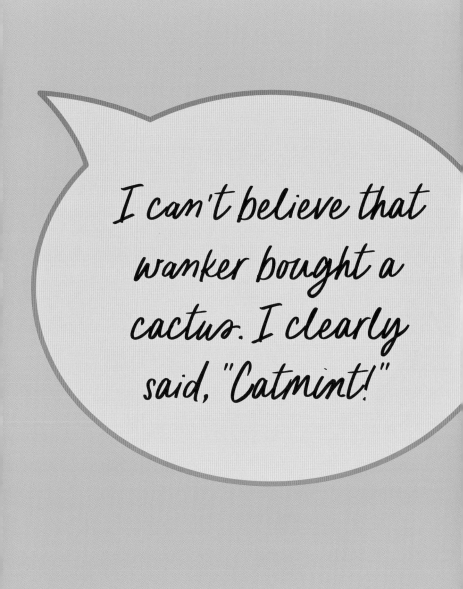

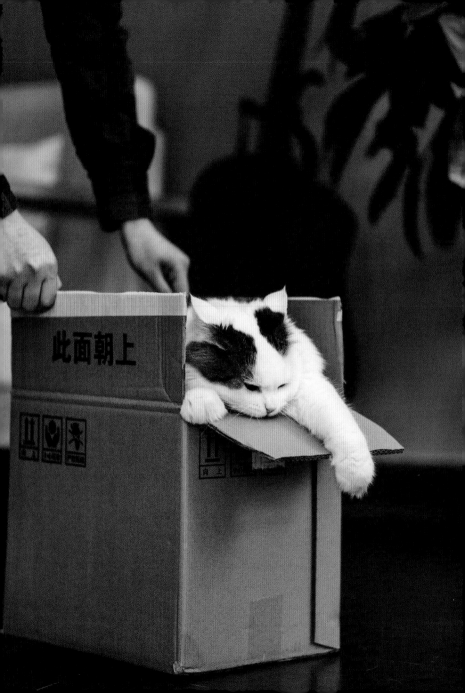

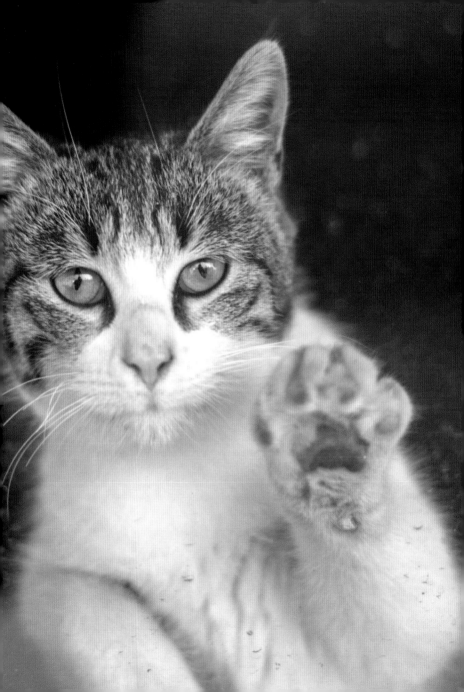

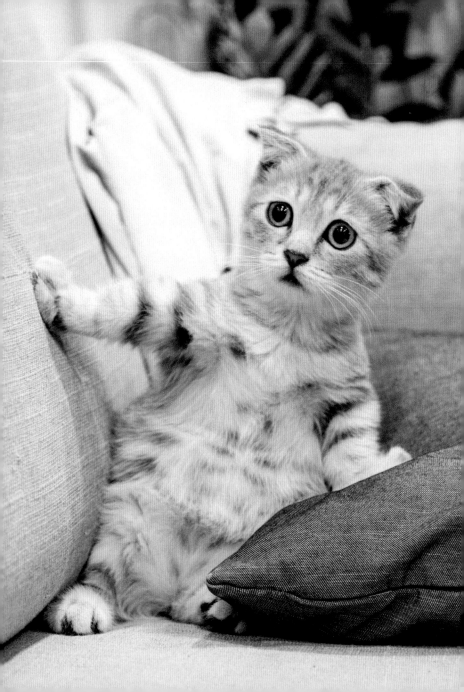

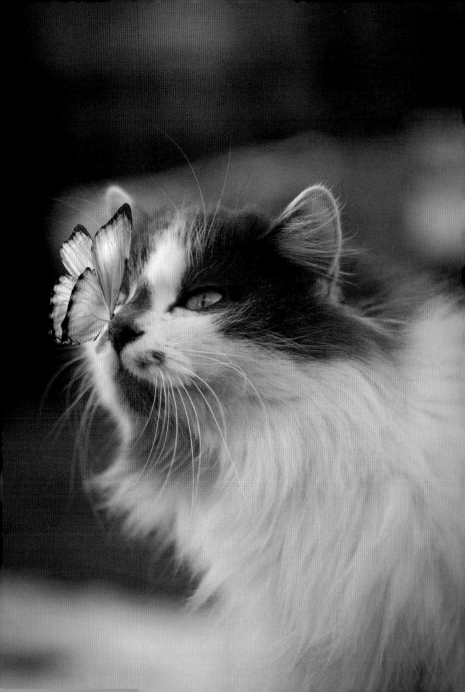

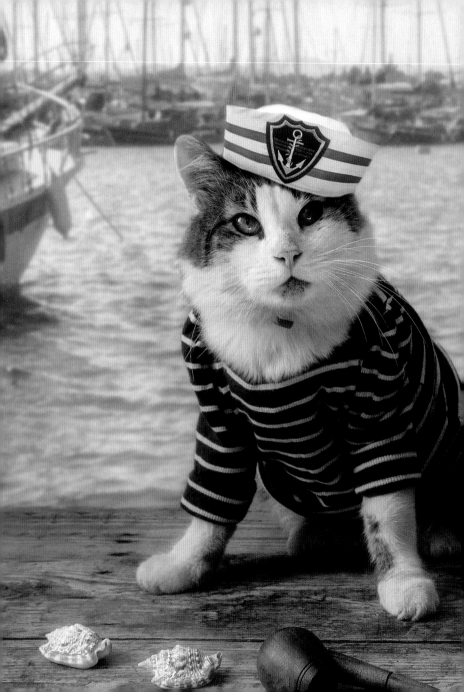

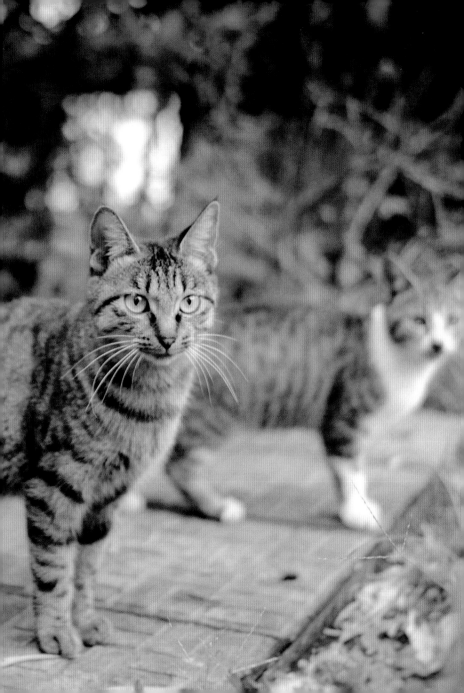

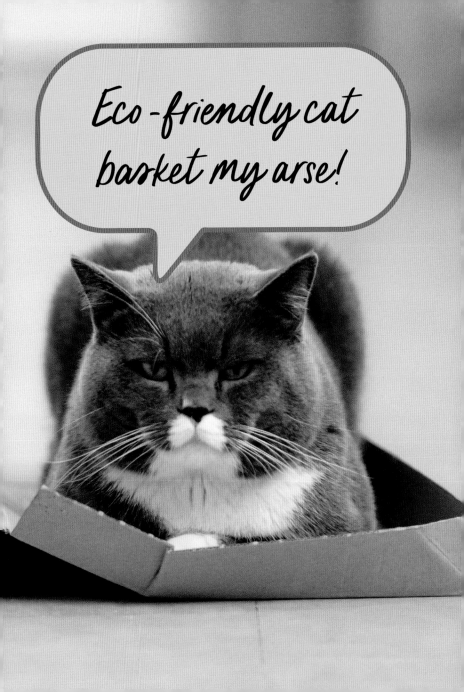

We had to go to Couples Therapy after Gerald tried to shag next door's Siamese

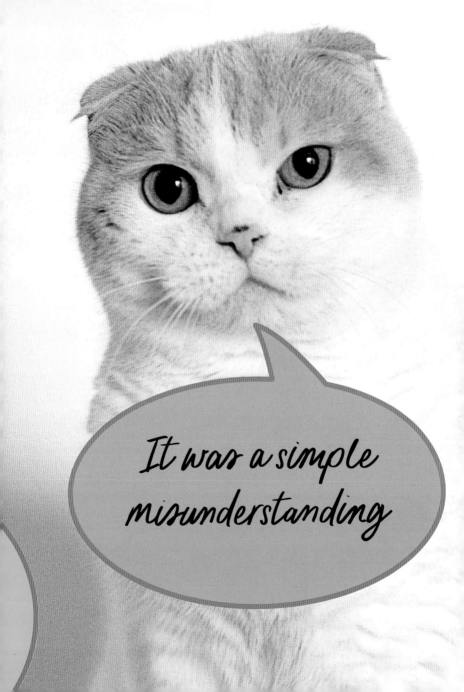

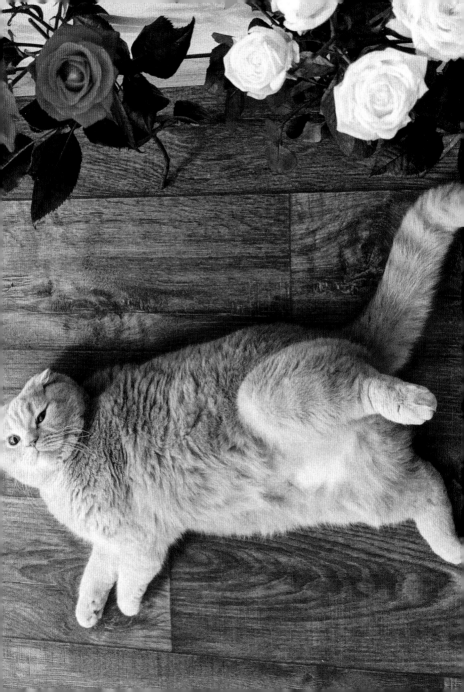

Yes, I am silently judging you... and your cat biscuits from the Pound Shop

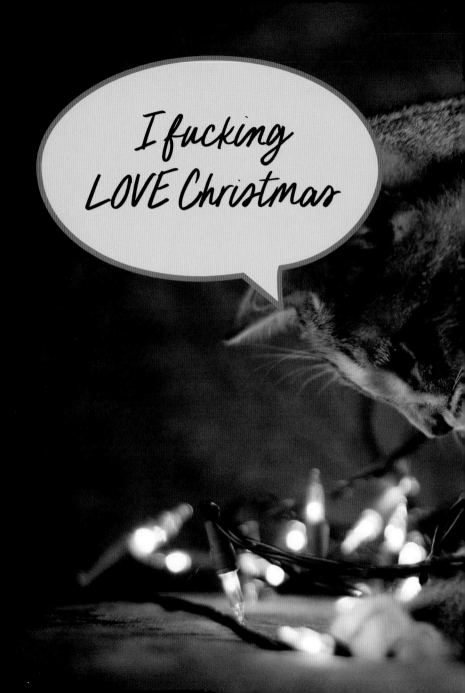

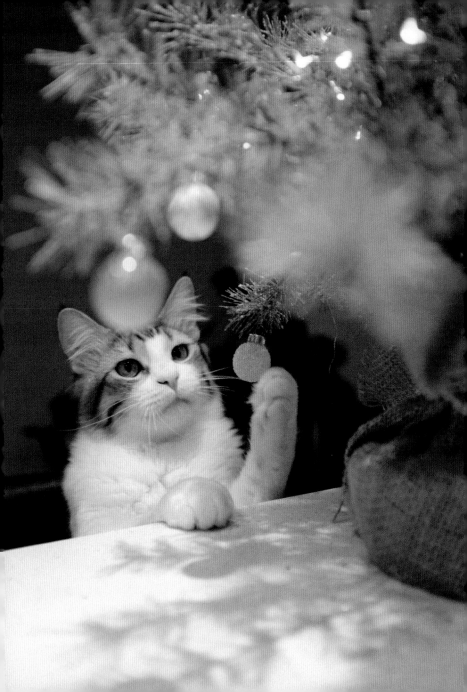

Aaaaw, 'Pussy's first Xmas' and the DIMSHITS have left all the baubles within reach...

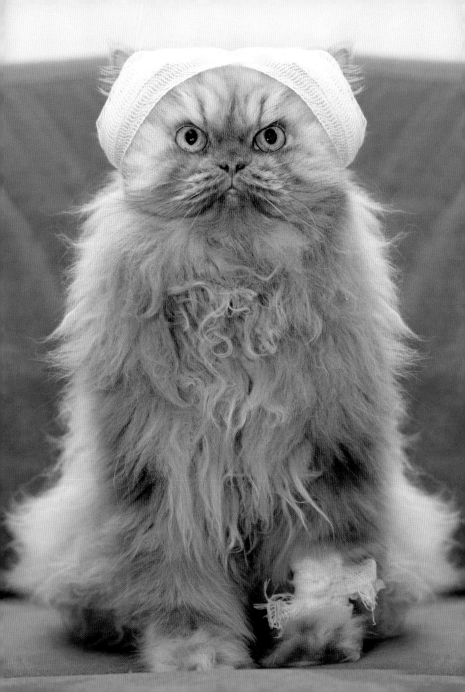

No, I'm not a big, grey, friendly rabbit. I'm a big nasty cat. And you are buggered

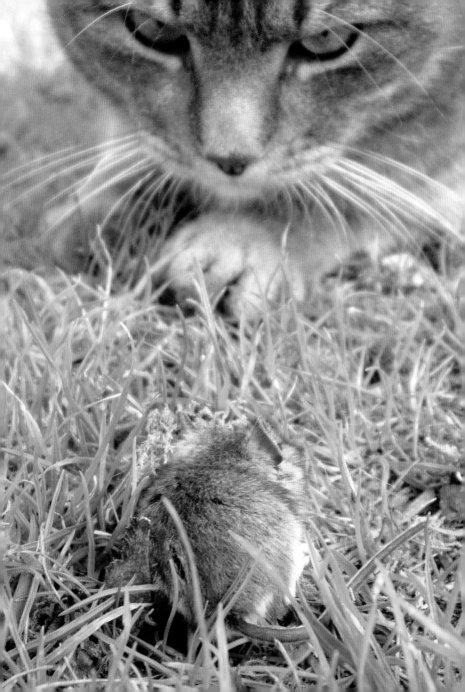

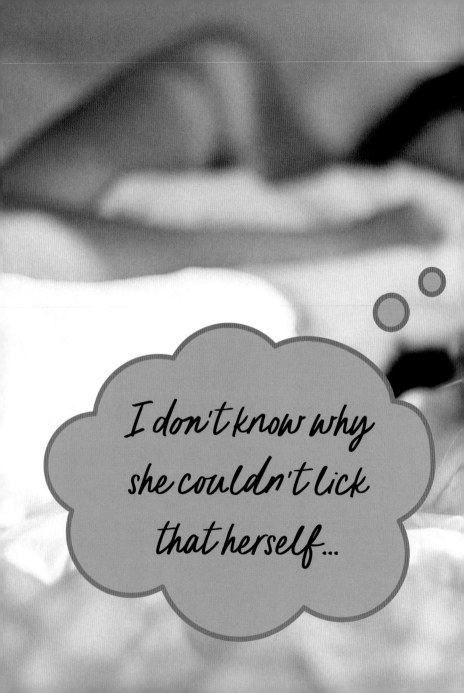

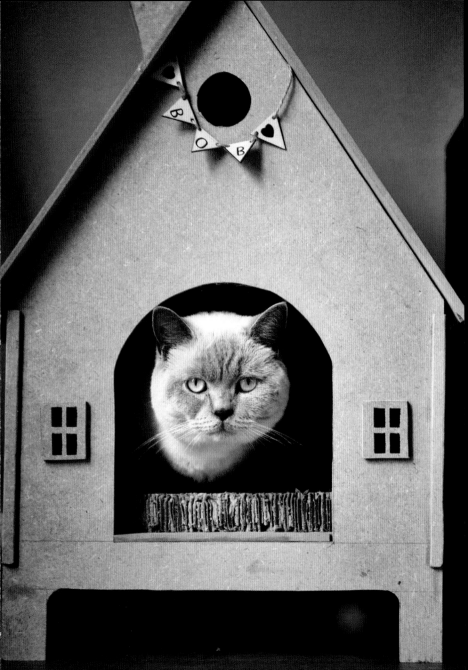

Go on then, bore me shitless about what you can do with an Excel spreadsheet

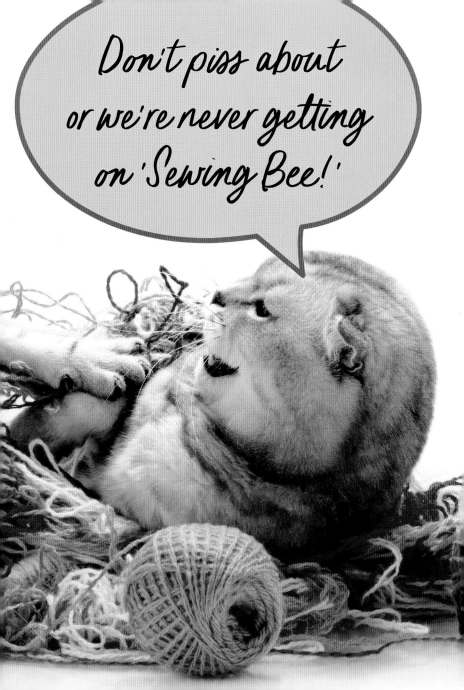

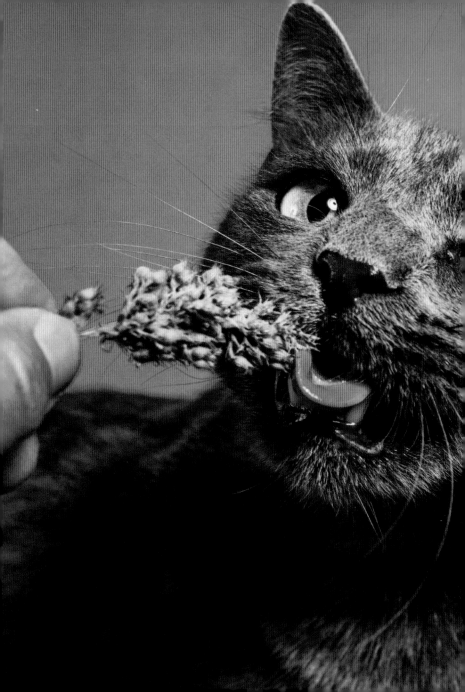

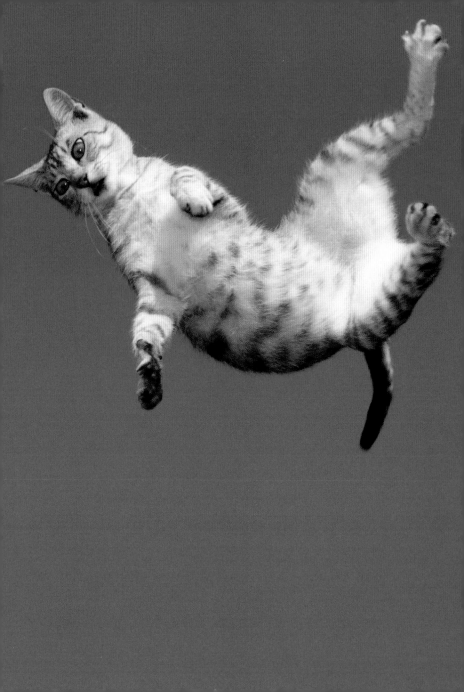

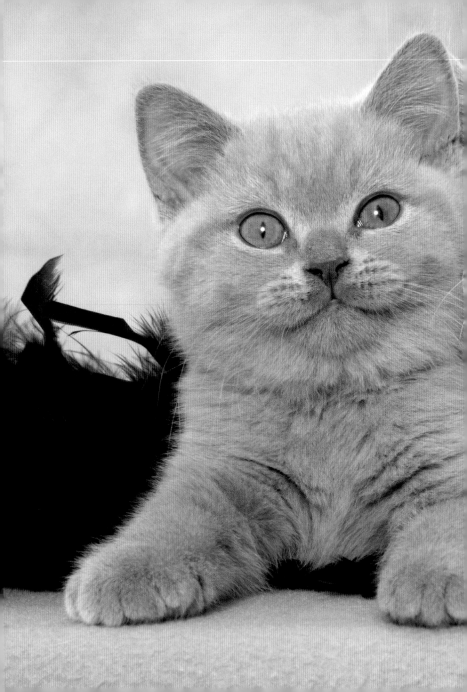

Mum says we can have a sleepover...
... and do Soft Drugs!

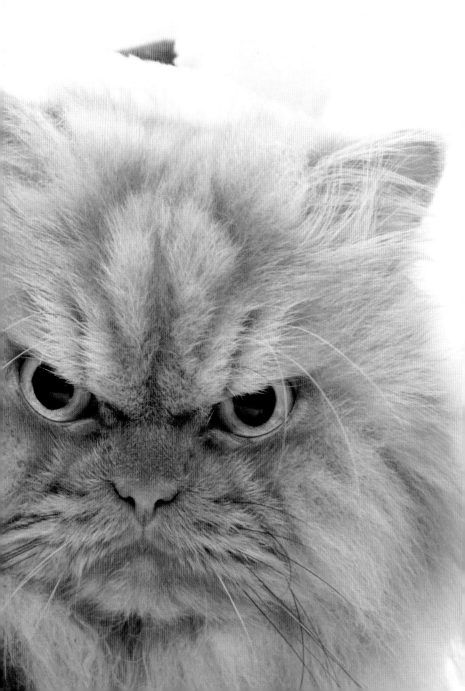

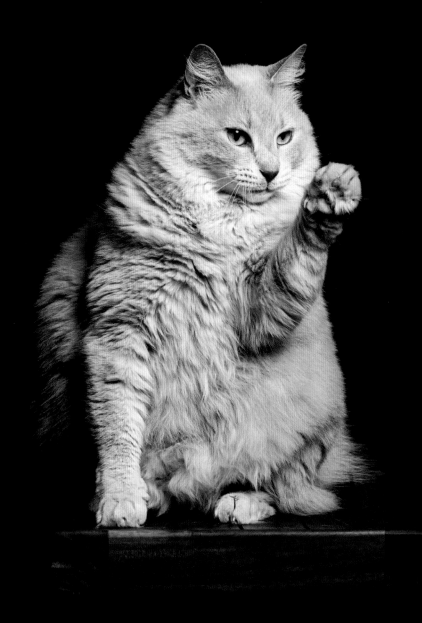

BELLA - the wanky name they gave me

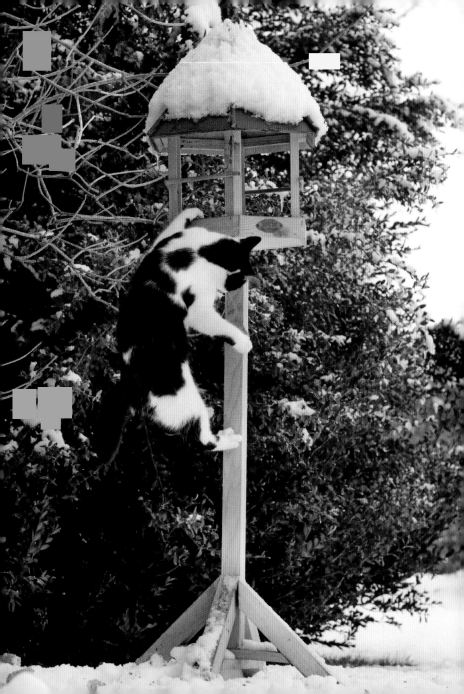

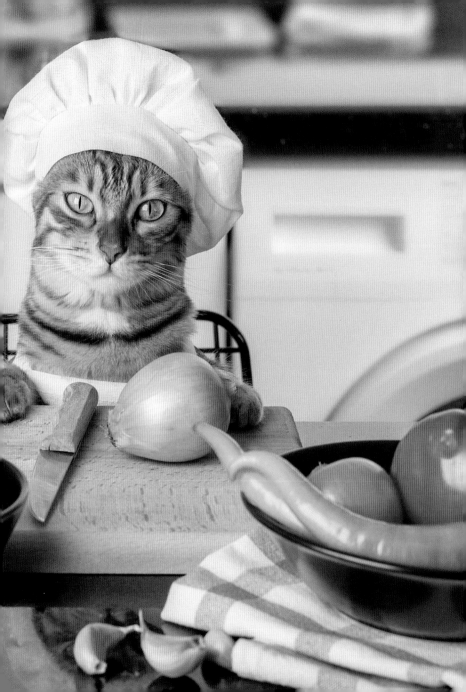

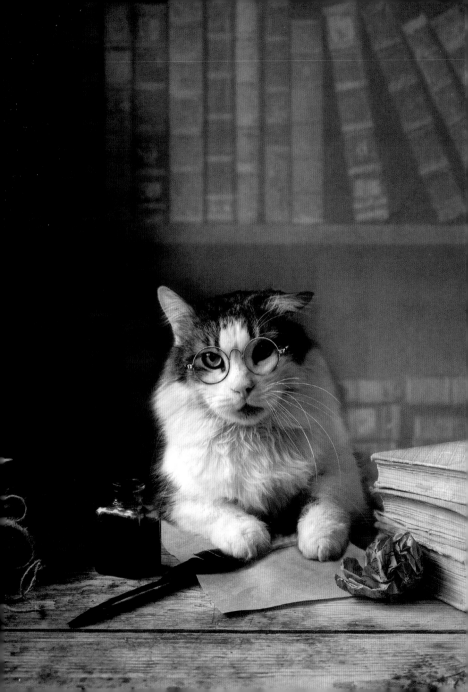

And I suppose
this is 'A Tale of
Two Kitties'...

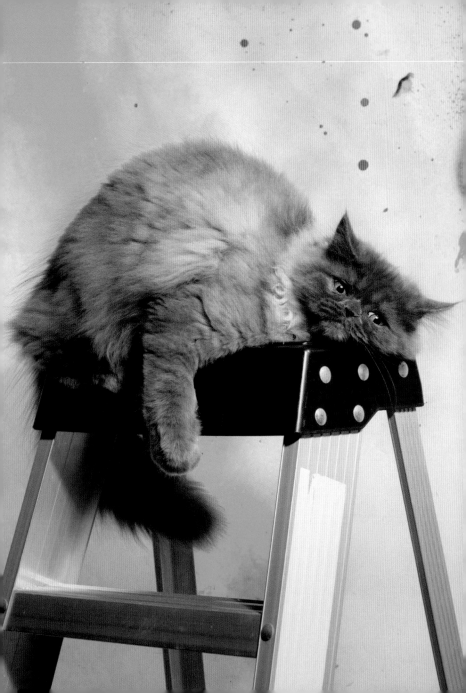

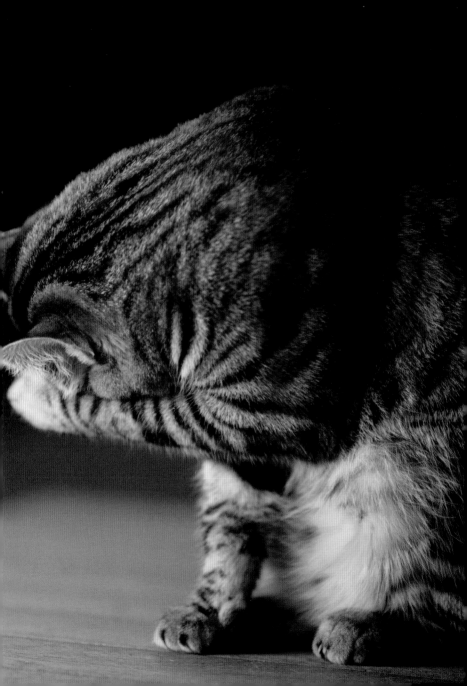

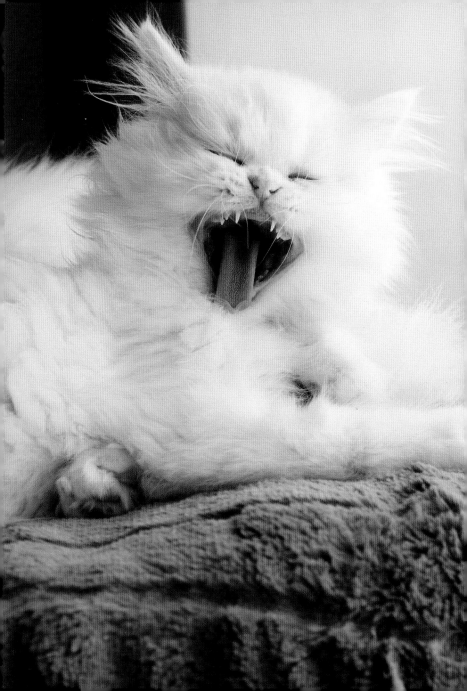

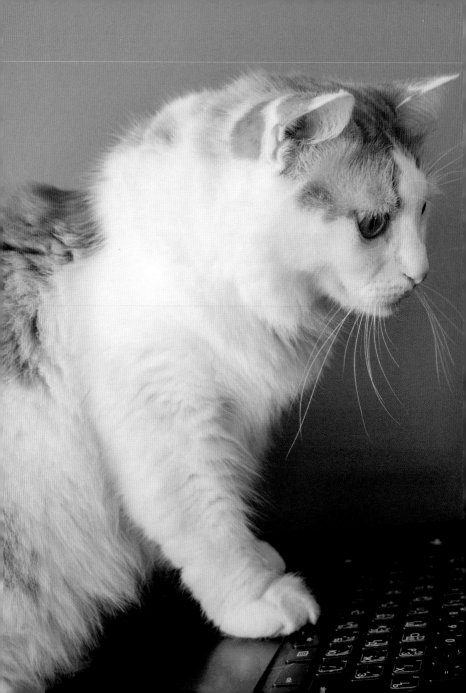

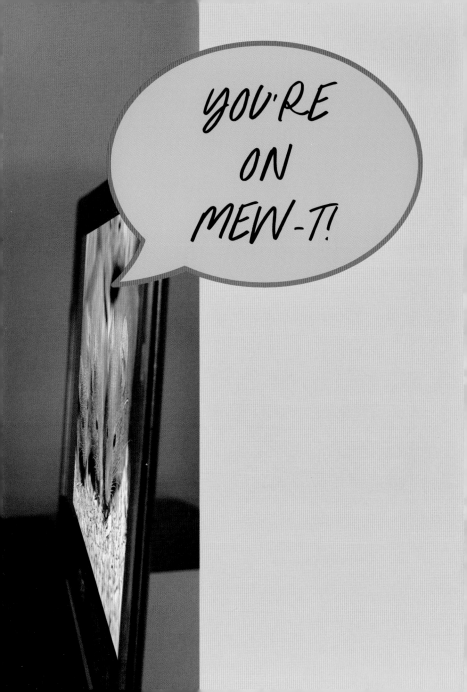

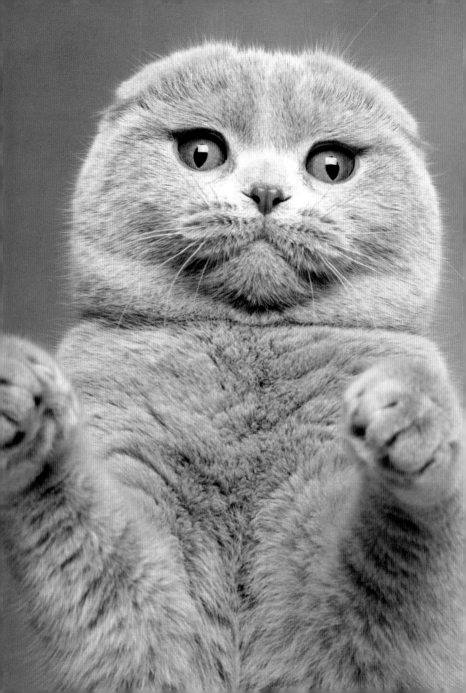

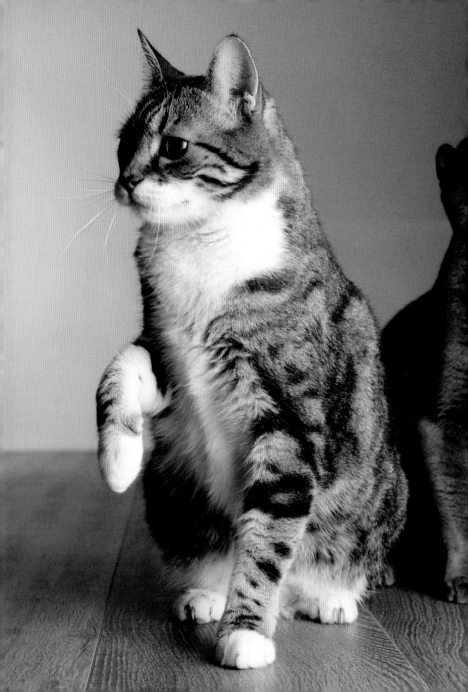

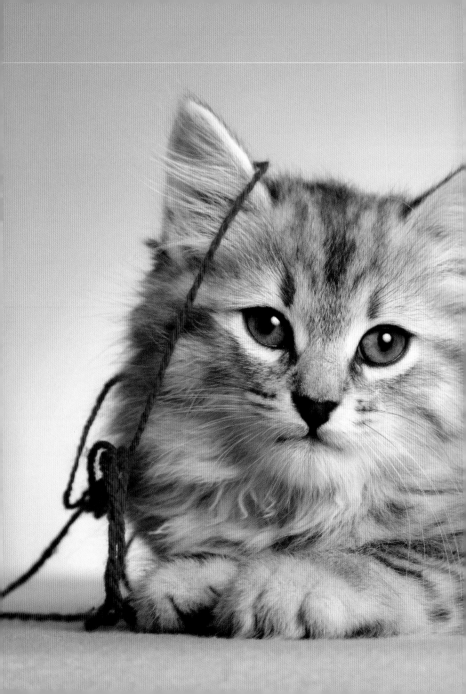

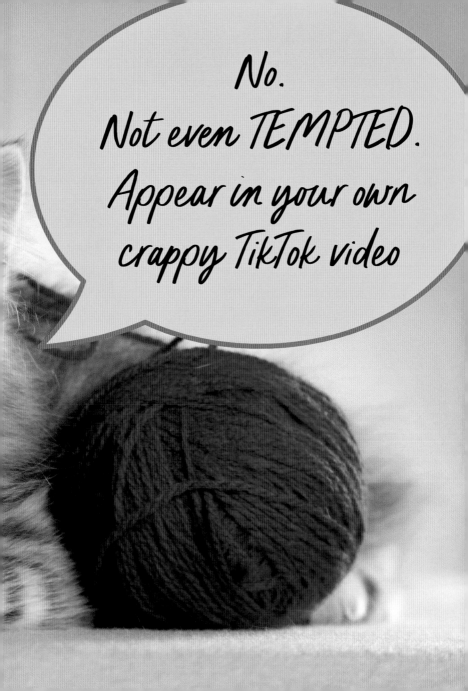

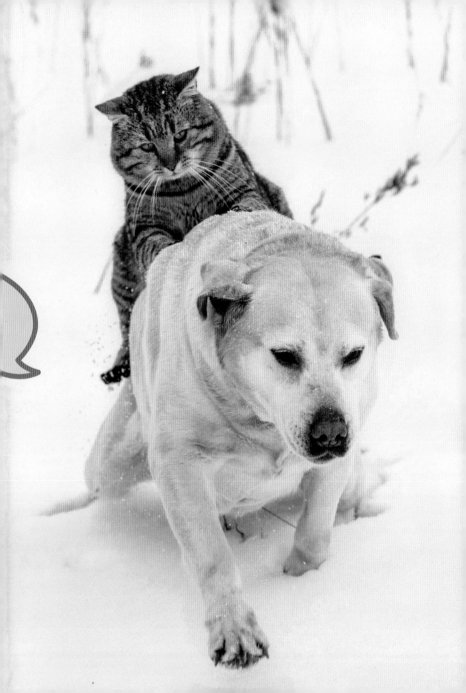

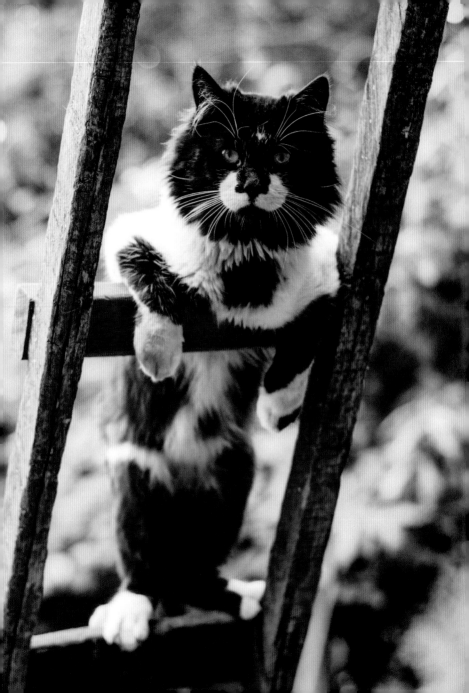

... I've forgotten the surfboard

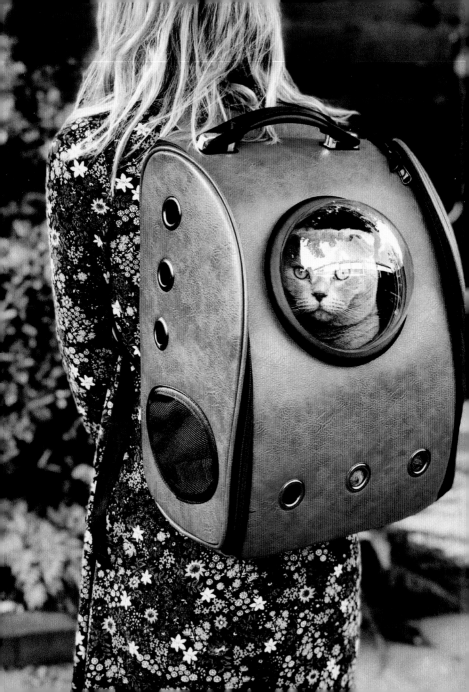

Picture Credits